SQUARE
MANDALAS
COLORING BOOK

ALBERTA HUTCHINSON

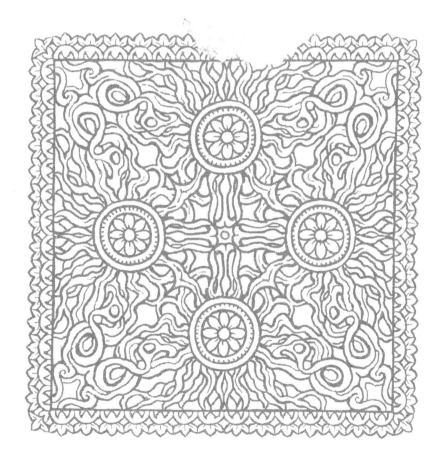

DOVER PUBLICATIONS, INC.
MINEOLA, NEW YORK

NOTE

Mandala is a Sanskrit word meaning "circle." It was originally used to refer to religious art in the Hindu and Buddhist traditions. Today we often use the term mandala to refer to any type of geometric pattern or design. In this coloring book you will find 31 dazzling mandalas, all within the borders of a square. Designed by noted artist Alberta Hutchinson, they offer hours of challenging fun to all coloring book aficionados.

Bibliographical Note

Square Mandalas Coloring Book is a new work, first published by
Dover Publications, Inc., in 2012.

International Standard Book Number

ISBN-13: 978-0-486-49094-6
ISBN-10: 0-486-49094-7

Manufactured in the United States by RR Donnelley
49094708 2015
www.doverpublications.com

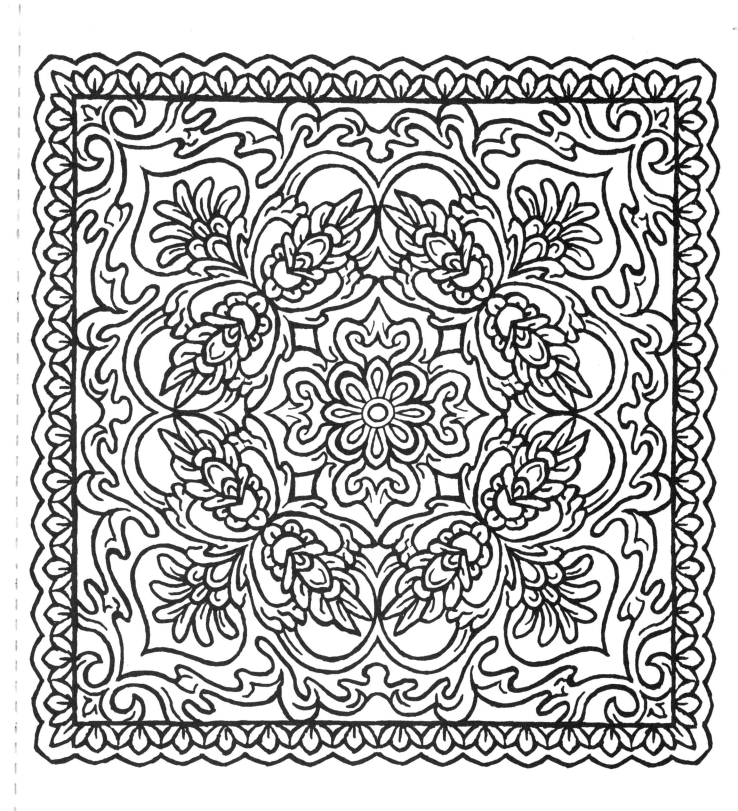

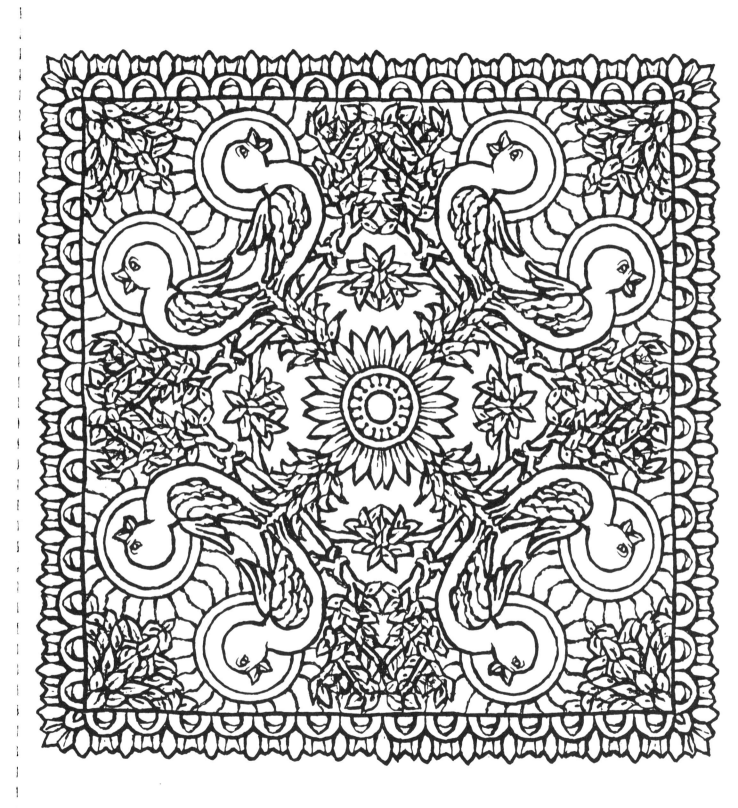

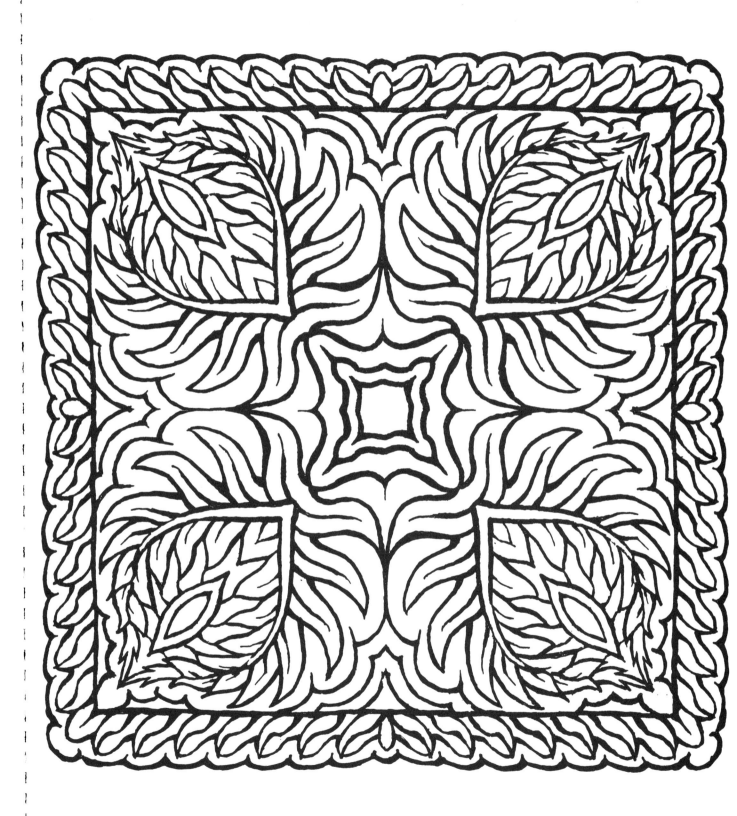

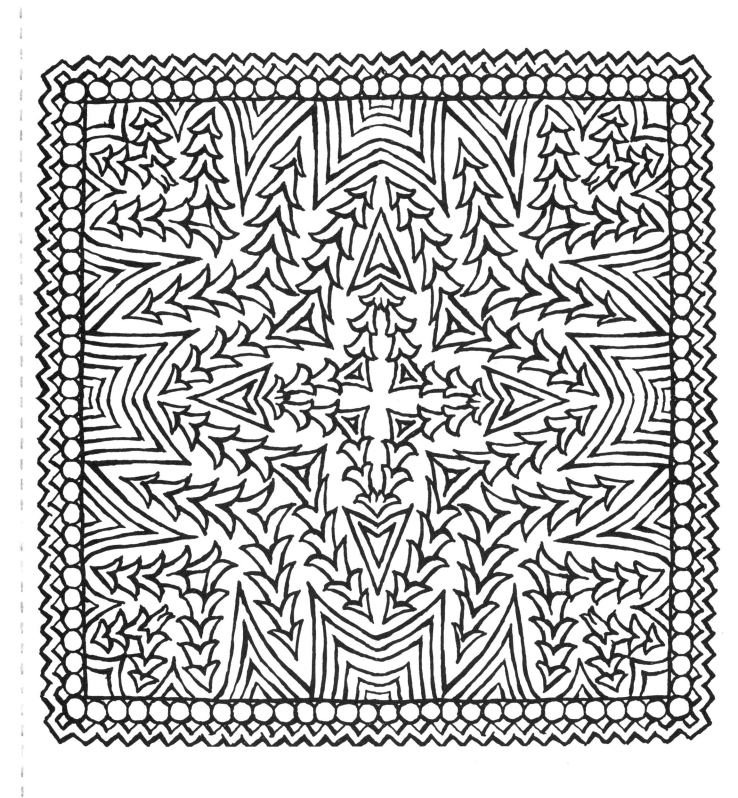

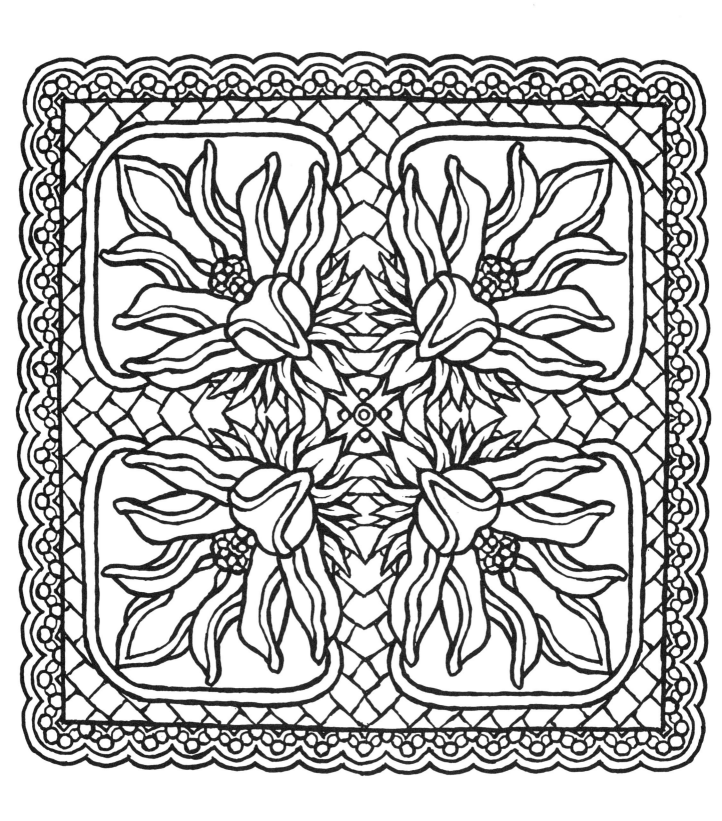

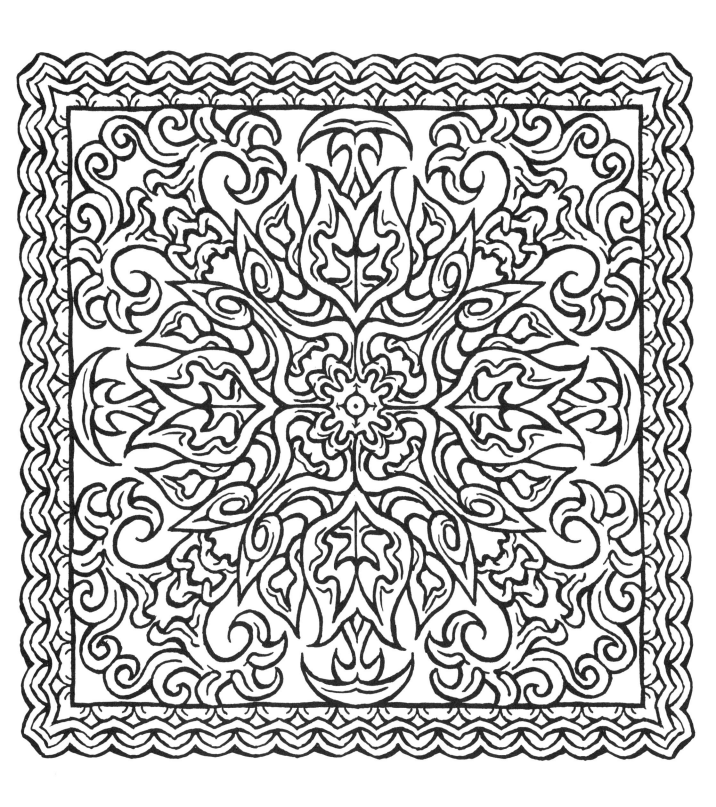

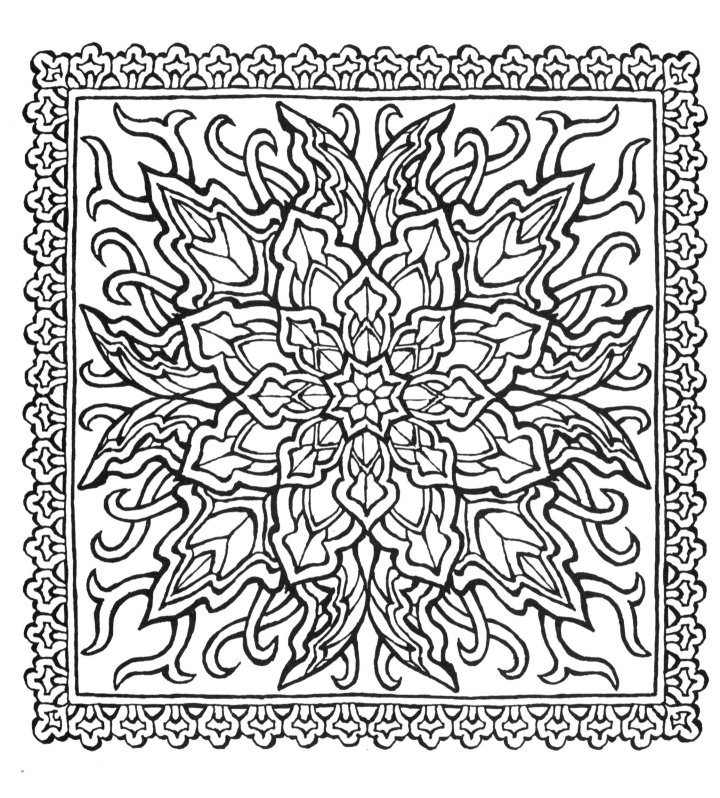

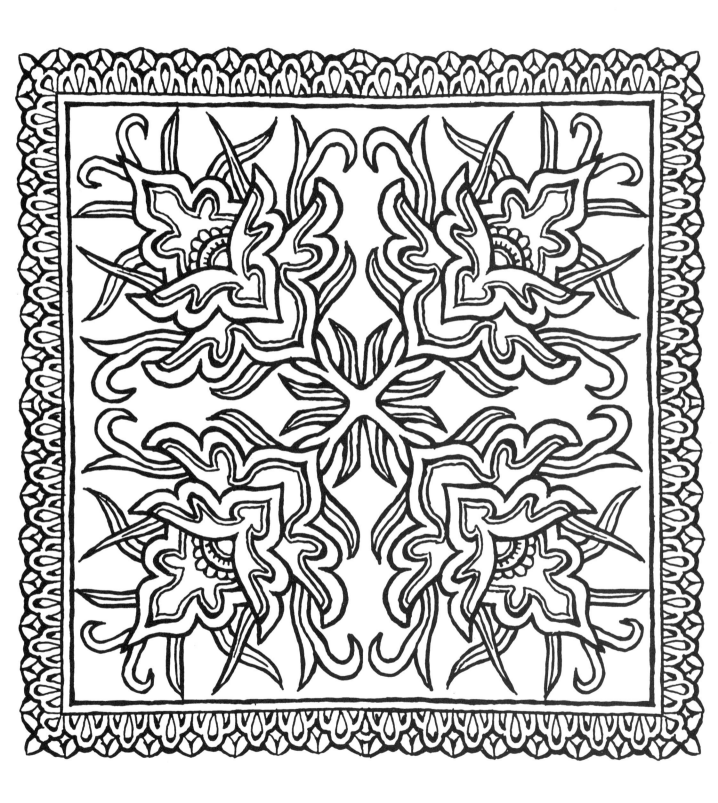

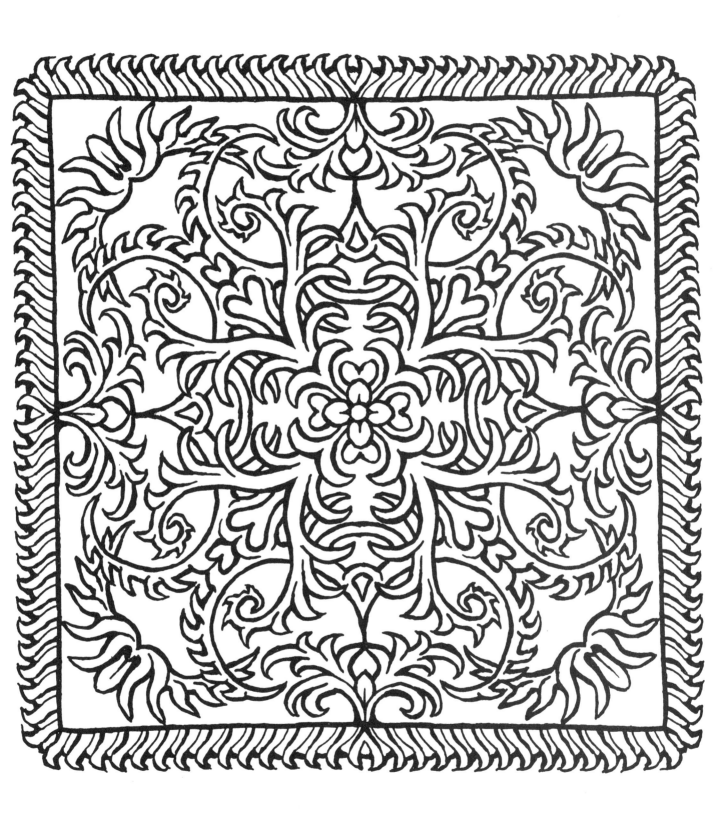

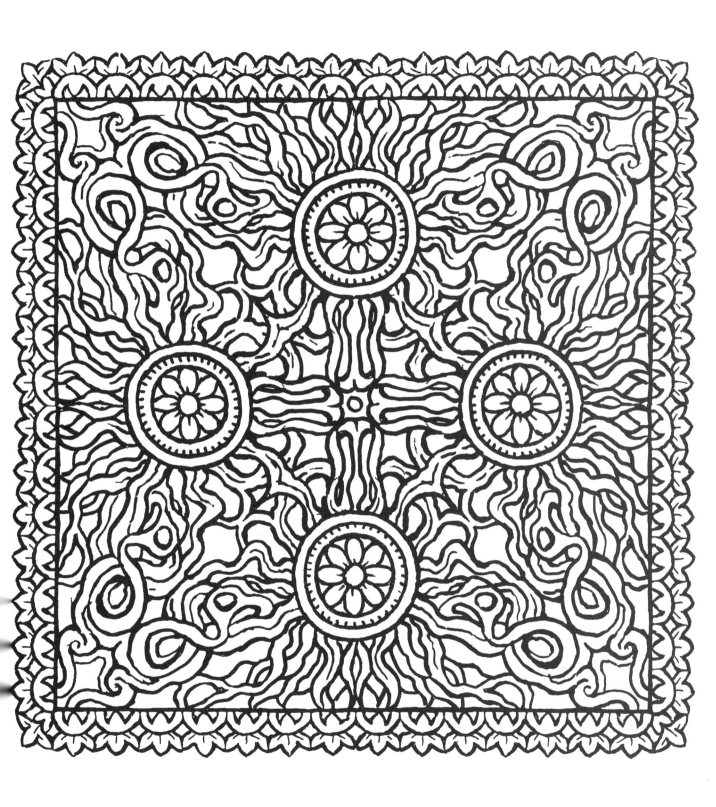

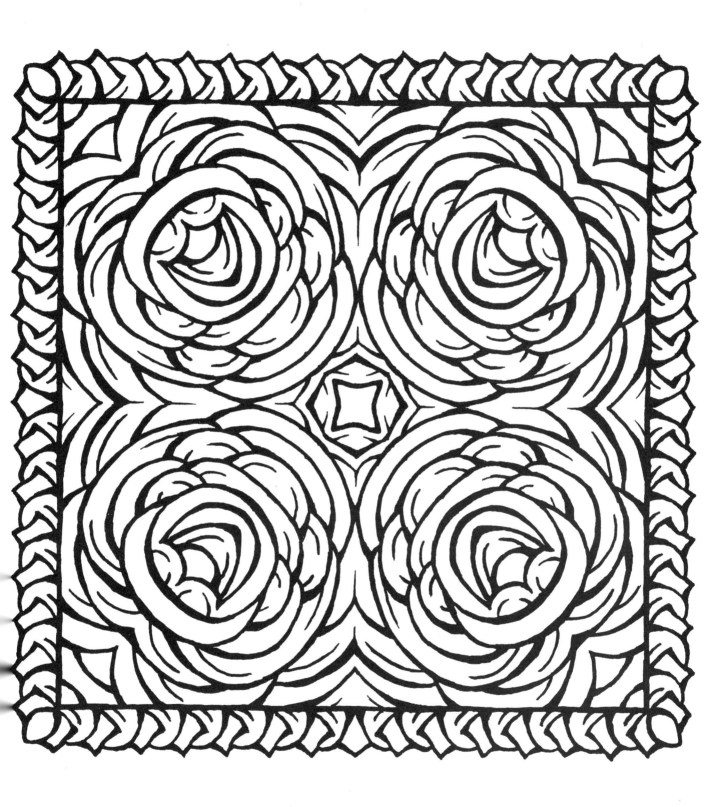

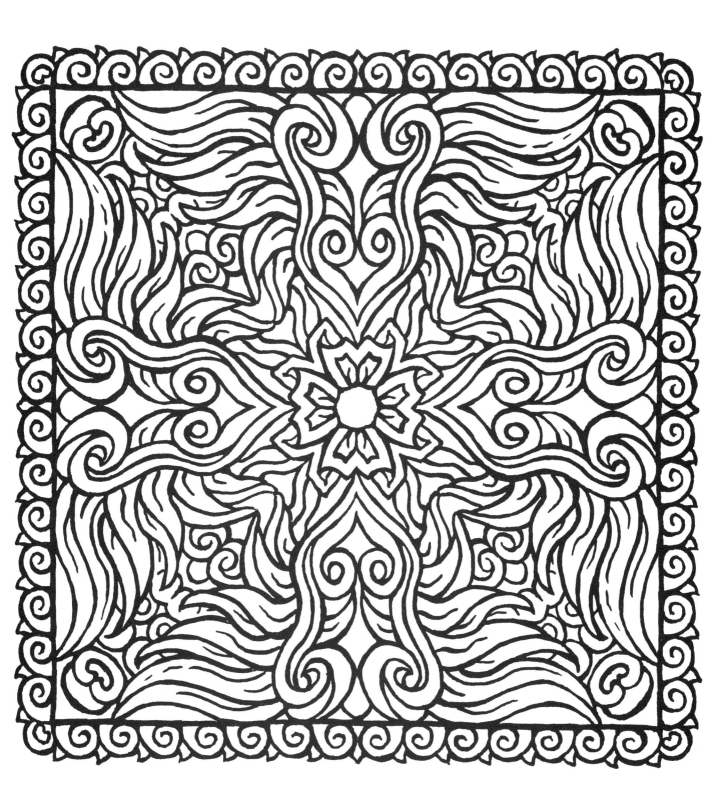

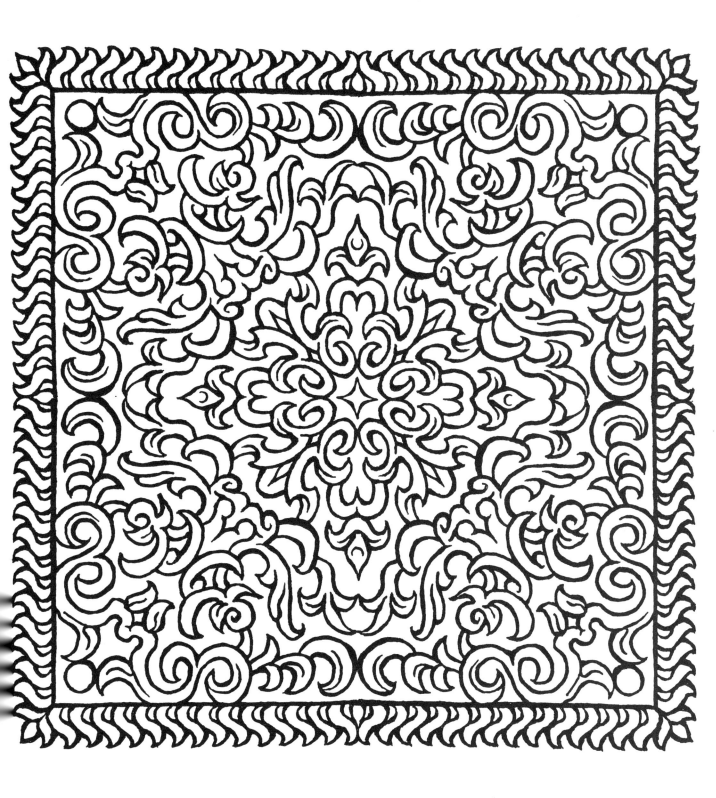

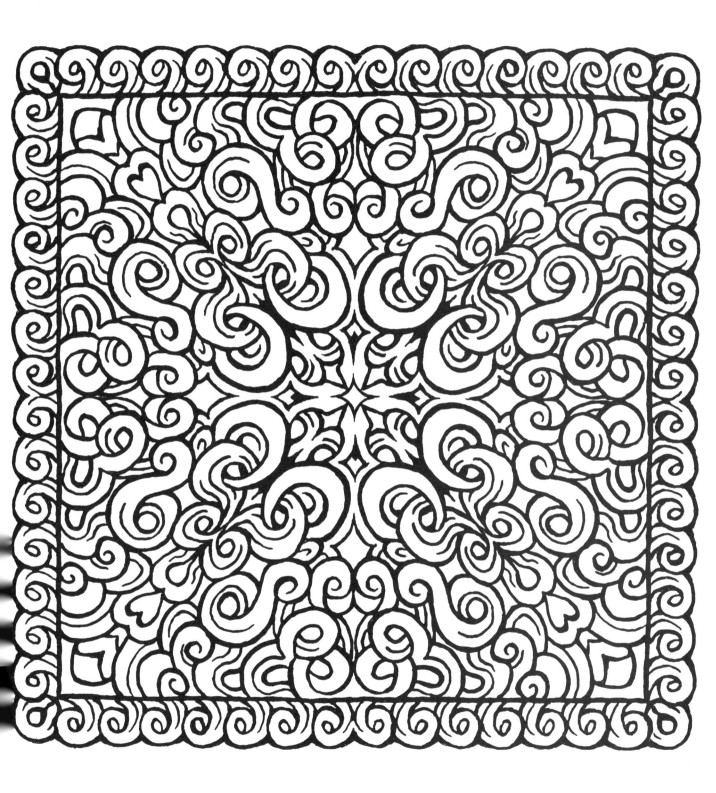

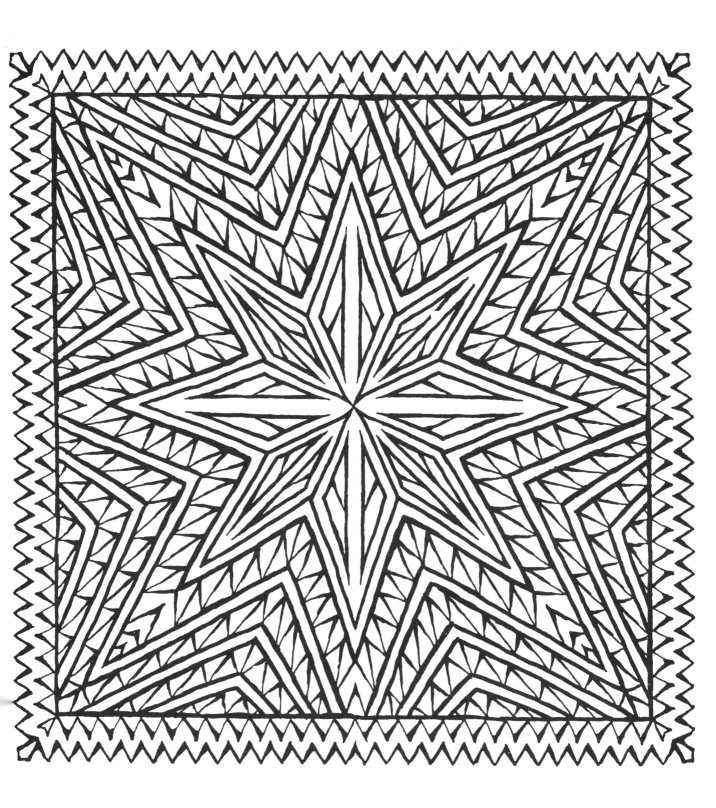

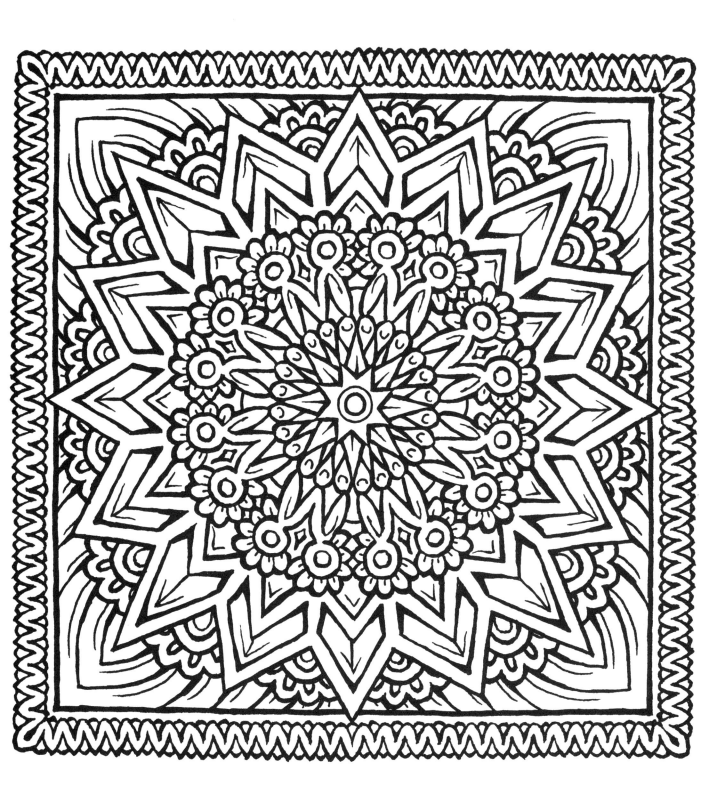

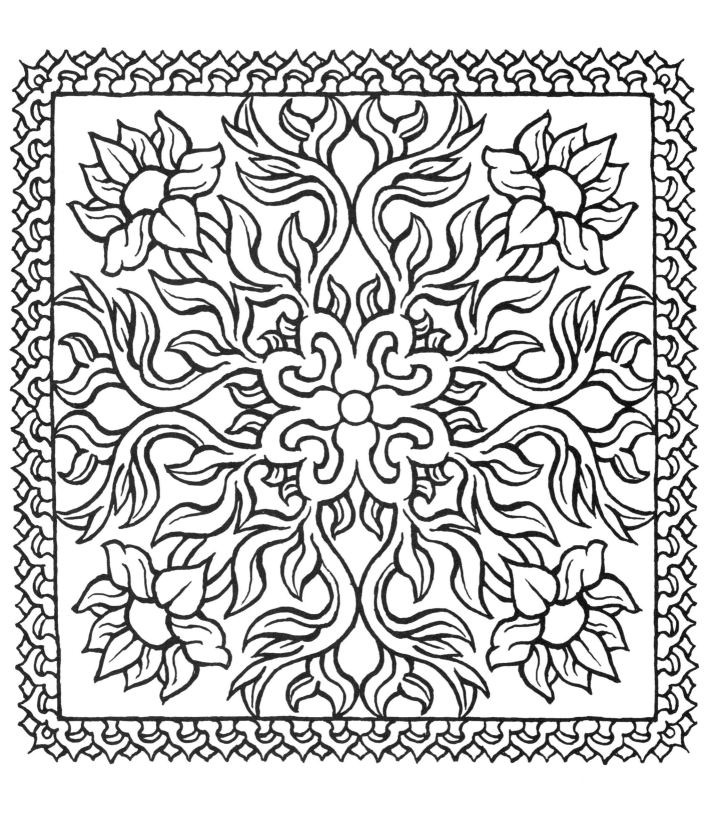

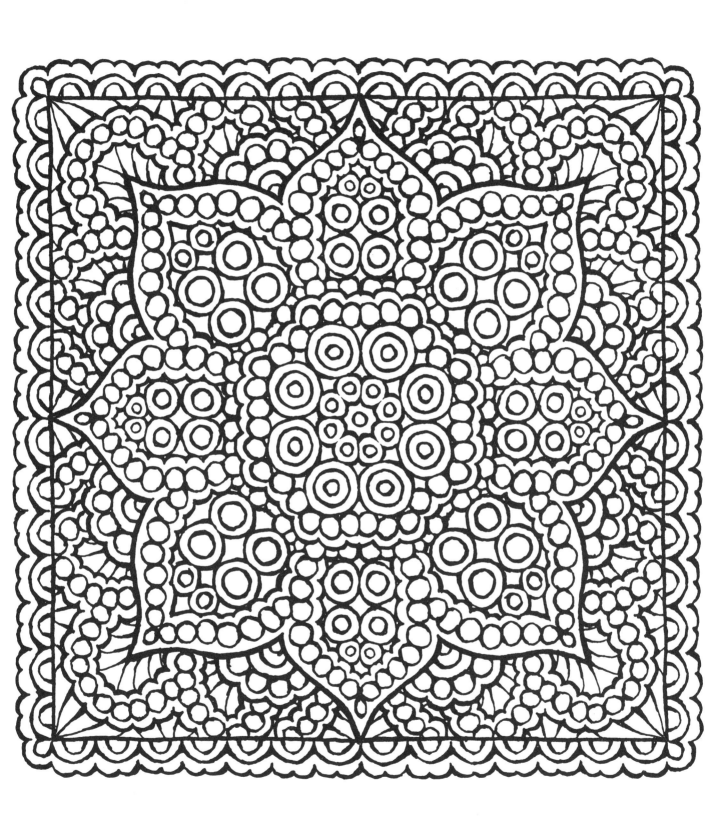

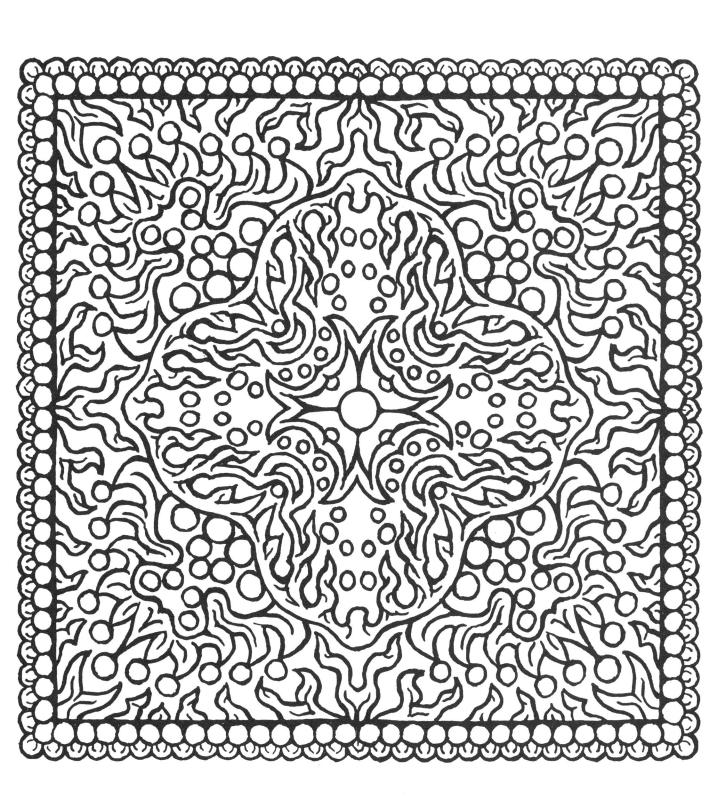

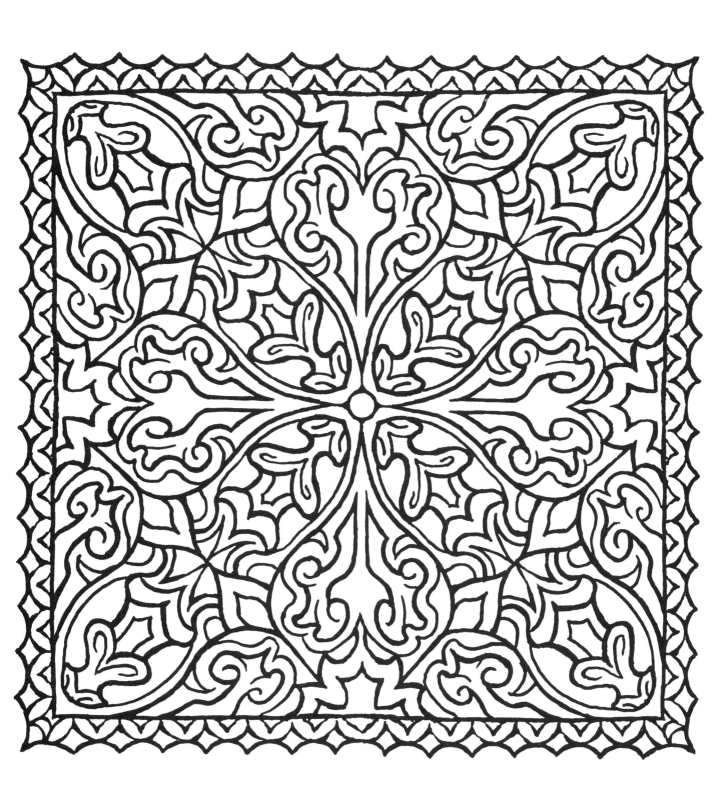

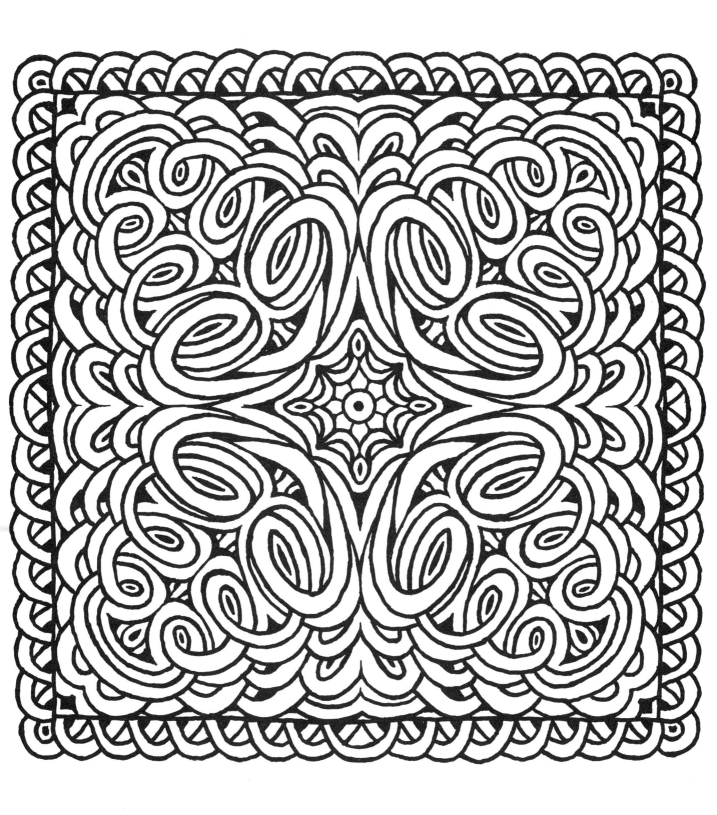

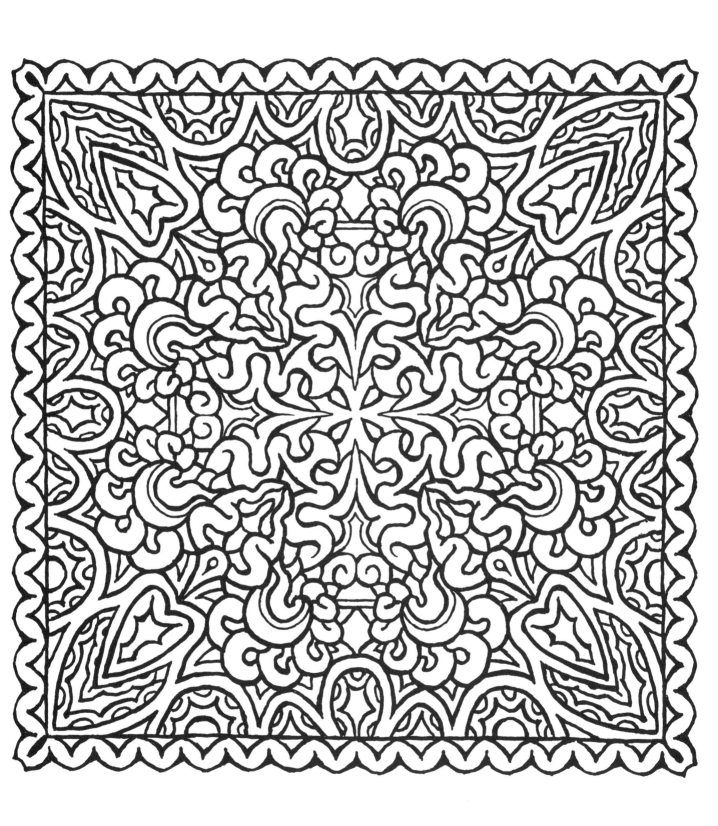

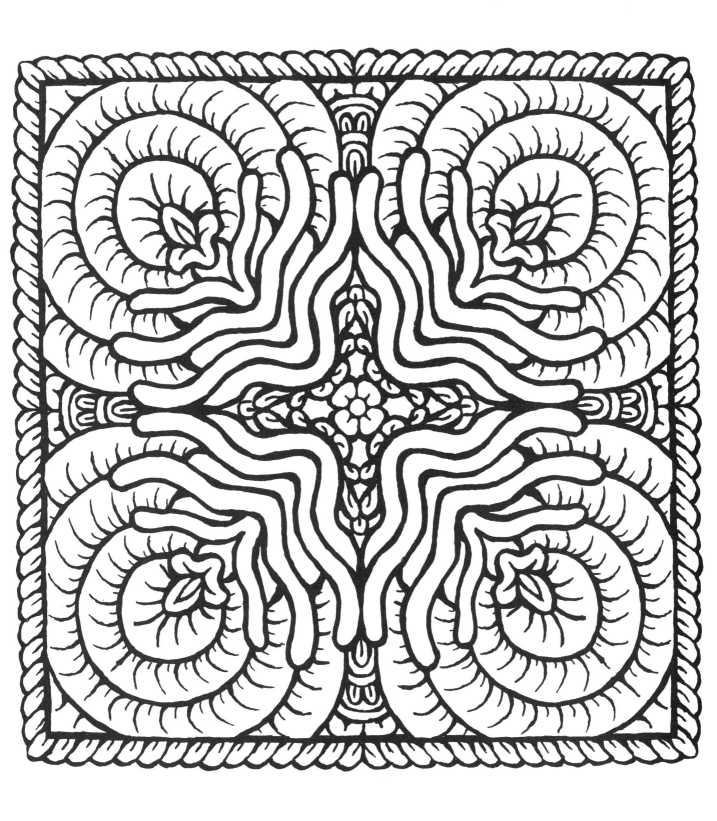

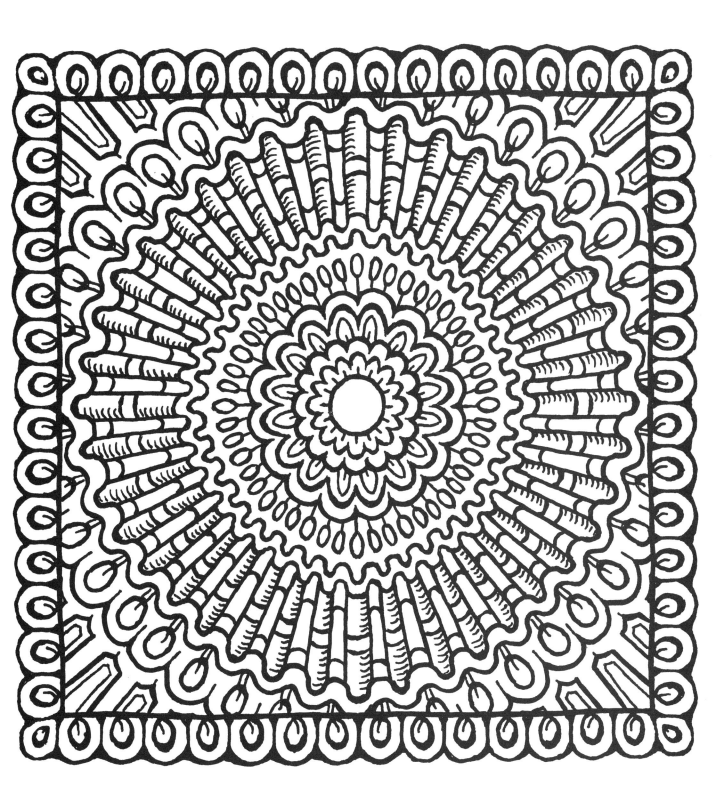

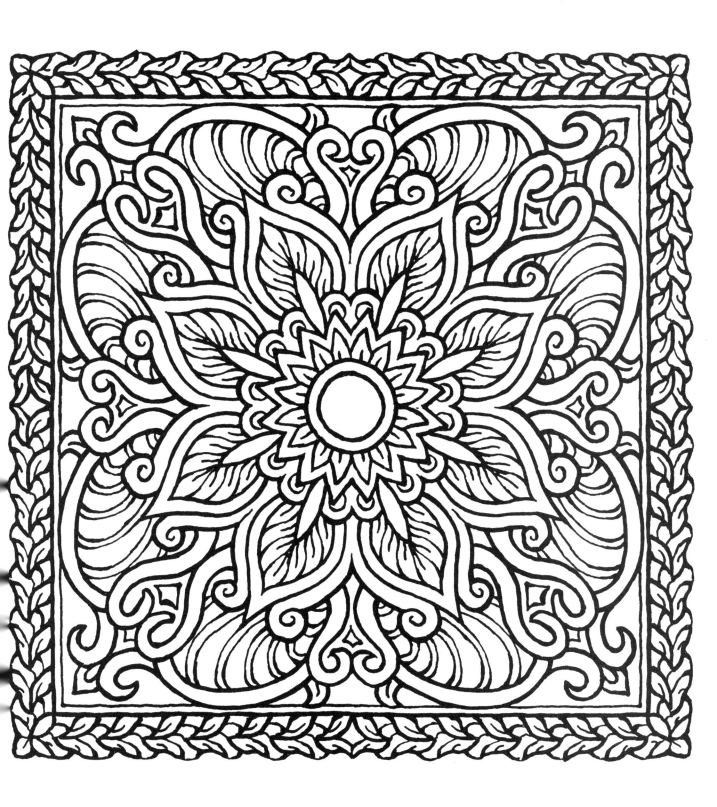

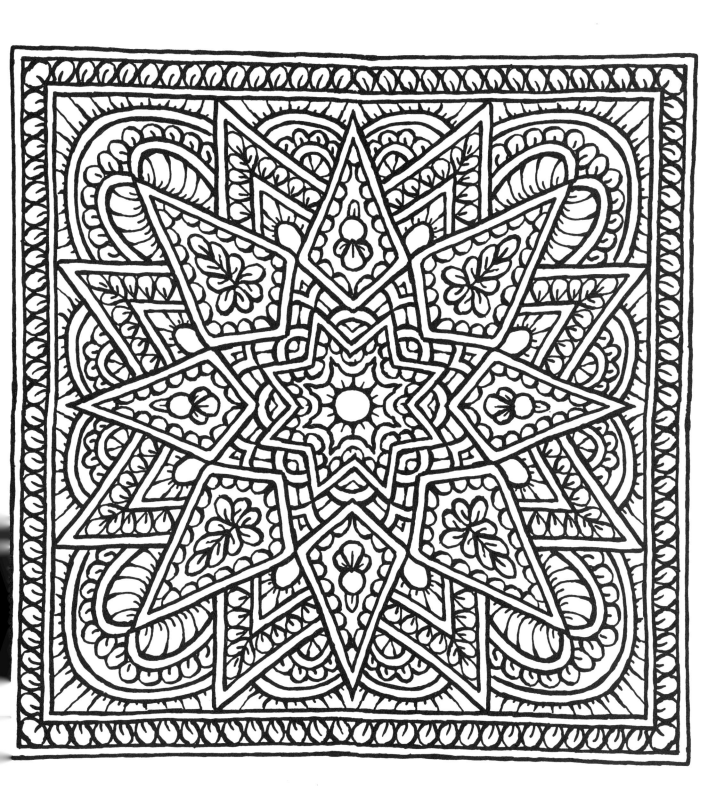

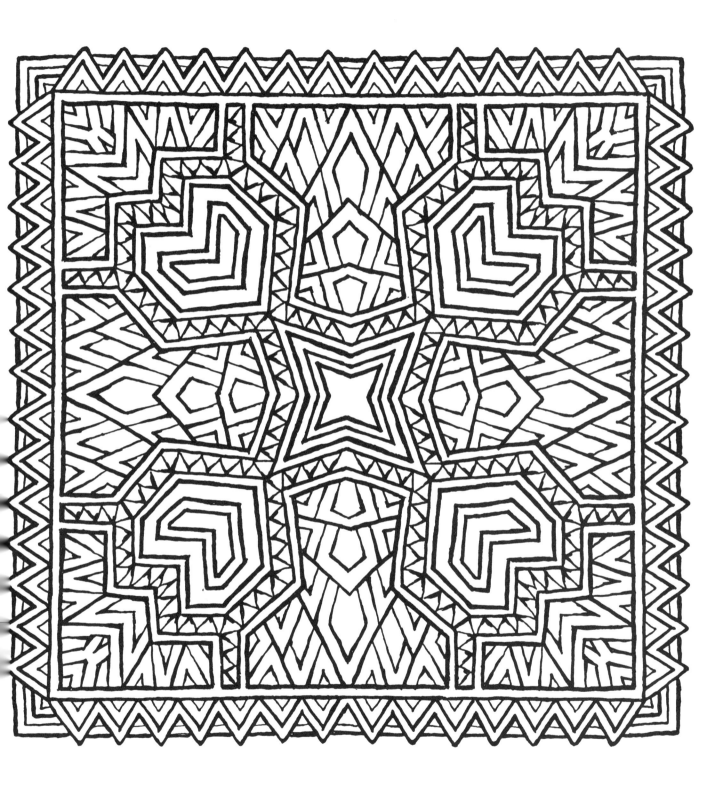

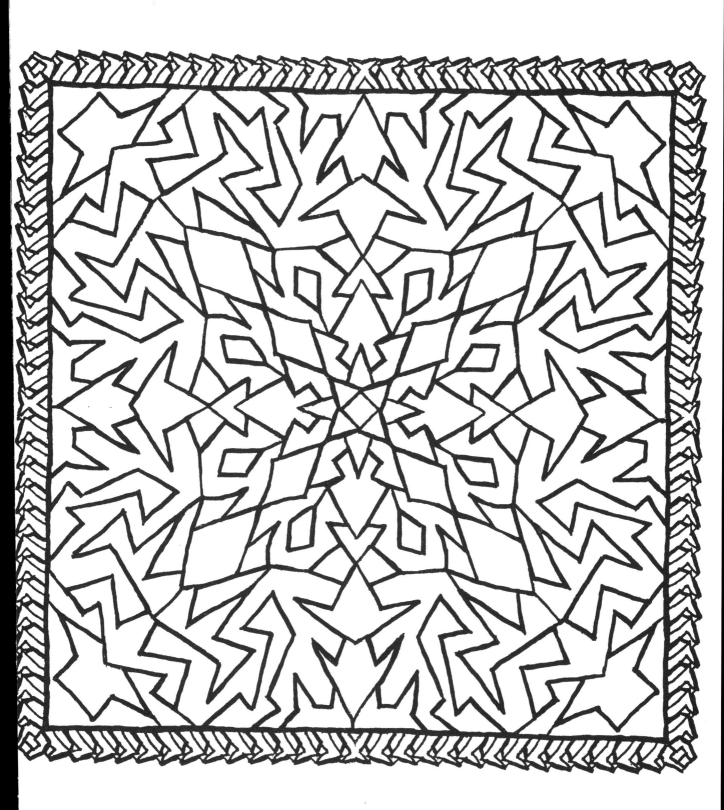

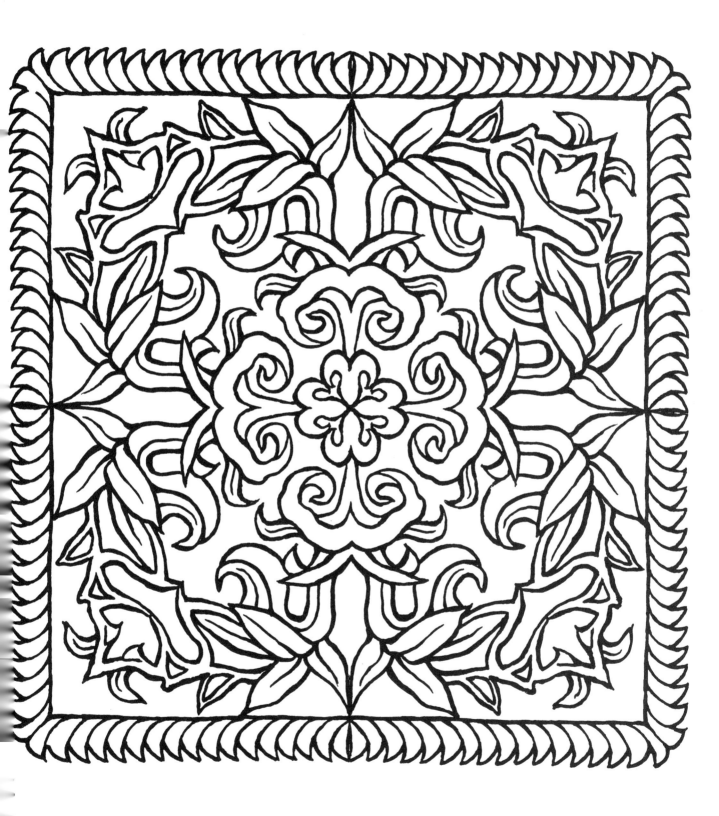

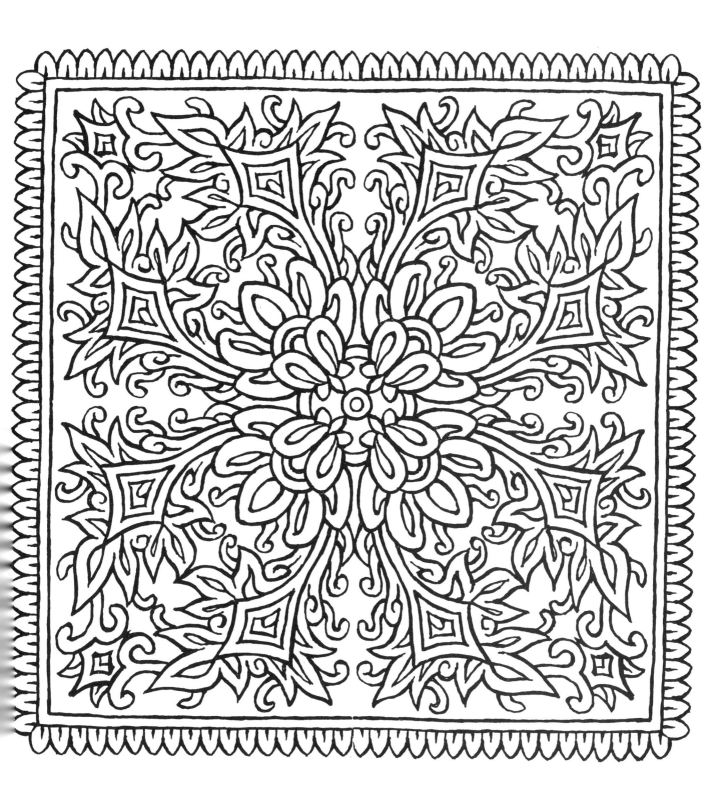